BEDAZZLED

5,000 Years of Jewelry

THE WALTERS ART MUSEUM

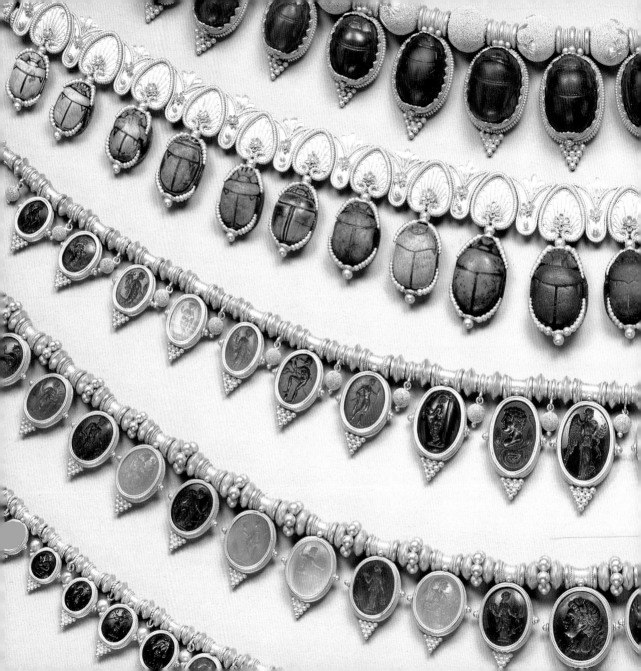

BEDAZZLED

5,000 Years of Jewelry

THE WALTERS ART MUSEUM

Sabine Albersmeier

The WALTERS
ART MUSEUM
BALTIMORE

in association with

g
D GILES LIMITED
LONDON

All measurements are in inches and centimeters;
Height precedes width precedes depth.
All images are reproduced throughout larger than actual size.

For the Walters Art Museum:
Edited by Deborah E. Horowitz
Photography by Susan Tobin

For GILES:
Copy-edited and proofread by Sarah Kane
Designed by Peter Ling
Produced by GILES, an imprint of D Giles Limited
Printed and bound in China

Front cover illustration: Bracelet from the Olbia treasure, Greek, 1st century B.C.
Back cover illustration: Pansy brooch, French (Paris), ca. 1903

FOREWORD

With an eye for innovation and craftsmanship, Henry Walters acquired a breathtaking collection of jewelry that still dazzles and fascinates today. During the late 19th and early 20th centuries, he visited World's Fairs and universal expositions and purchased the latest creations from some of the most famous names in jewelry making, including René Lalique and Tiffany & Co. His tastes extended well beyond the cutting-edge designs of the craftsmen of his day, however, and Walters' holdings of jewelry are as diverse as his collections of paintings, sculpture, and decorative arts. The museum's collection has been augmented through the purchase of select pieces as well as through the generosity of donors and today spans over 5,000 years and includes a vast range of artistic and cultural styles.

Presented here are some of the most notable objects acquired by Henry Walters, complemented by generous loans from the extensive Zucker family ring collection. Indeed, my encounter with that collection, in Ben Zucker's Greenwich Village living room nearly 20 years ago, was a revelation. I would not have dreamed that a collection from the later 20th century could match, and perhaps even surpass, the quality and breadth of the works Henry Walters had amassed nearly half a century earlier. I wish to express my sincere gratitude to the Benjamin and Barbara Zucker family for their encouragement and support of this project.

GARY VIKAN
Director

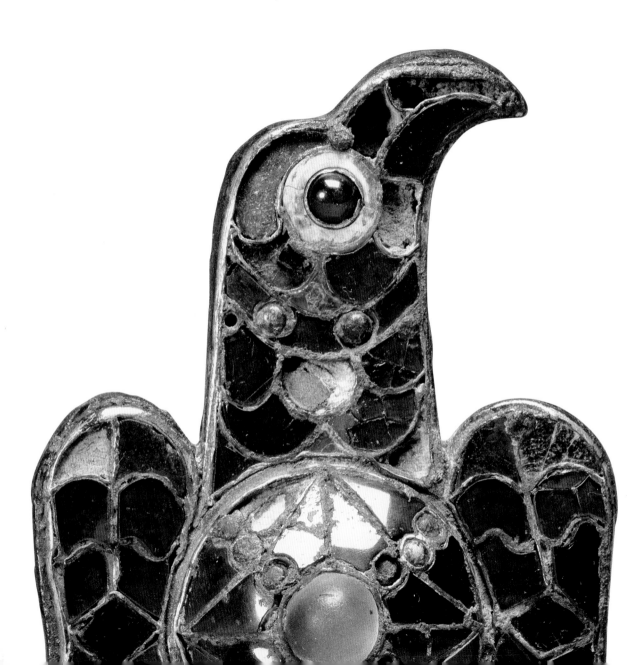

Introduction

The Walters Art Museum has one of the most distinguished, and certainly the most wide-ranging, collections of jewelry assembled by a private collector in the United States. Henry Walters (1848–1931) purchased a vast array of art from over five millennia, thereby continuing and significantly expanding the efforts of his father, William T. Walters (1819–94), a railroad magnate in Baltimore who started the collection by acquiring primarily contemporary and Asian art. Henry Walters collaborated with well-known dealers like the Seligman brothers, Joseph Brummer, and Dikran Kelekian, but also traveled to Europe himself in search of new objects. His widespread interests led to a collection of about 25,000 pieces, which represent an extensive variety of cultures, time periods, and geographical areas. The jewelry he assembled encapsulates this diversity and dates from about 3000 B.C. through the early 20th century. He visited and commissioned jewelry from some of the leading jewelry makers and workshops of his time, including Peter Carl Fabergé in St. Petersburg and Giacinto Melillo in Naples. At his death in 1931, he bequeathed his entire collection to the City of Baltimore "for the benefit of the public."

This highlights guide provides a glimpse of this magnificent collection and features some of its greatest masterpieces, including the Olbia bracelets, the Visigothic eagle *fibulae*, René Lalique's pansy brooch, and the extraordinary iris corsage ornament by Tiffany & Co. But it also brings to light some of the Walters' hidden treasures that are not on permanent display. These stunning examples demonstrate the depth and beauty of the museum's holdings as well as the remarkable eye for art and the generosity of its founders, William and Henry Walters.

The story of jewelry extends back to earliest human history. Prehistoric bracelets and necklaces were not simply objects of personal adornment but were believed to have magical and mystical power. Matters central to prehistoric life like hunting, fertility, and rank featured in many objects made out of natural

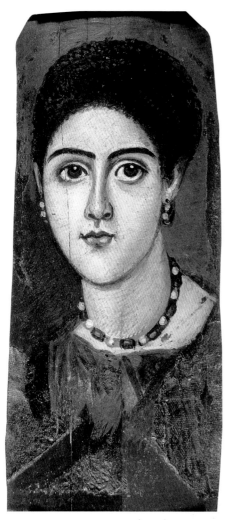

Mummy Portrait, Roman, 2nd century A.D., Egypt (Faiyum?), encaustic. The Walters Art Museum, 32.5.

elements such as flowers, leaves, and seeds. Figures of gods, heroes, mothers, and animals as well as signs and symbols carved out of bone, stone, and wood or formed from clay and later metal were thought to protect the bearer from all kinds of threats from the harsh environment.

Most of these age-old connotations could still be found in jewelry from the ancient Mediterranean world. Religious, magical, and protective significance remained inherent in many pieces, and social status was strongly expressed by the type, quality, and quantity of jewelry men and women wore. In Greek jewelry, delicate earrings, bracelets with animal-head terminals, and gold bead necklaces with multiple pendants were most common. Before the 3rd century B.C., inlaid stones were rare, but during the Hellenistic period (3rd–1st century B.C.), multicolored gemstones and glass became quite fashionable.

Although Greek artisans were renowned for their remarkable skill, the Etruscans were the real masters of the craft in the ancient world. They excelled in techniques such as filigree, repoussé, and especially granulation, a sophisticated technique they perfected as early as the 7th century B.C. It was much admired by famous 19th-century workshops like Castellani in Rome, which tried, but never quite managed, to re-create it.

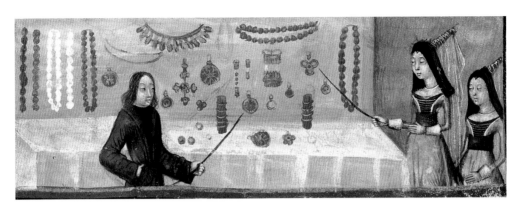

Marginal Miniature from a Book of Hours, Two ladies choosing jewelry in a goldsmith's shop, Flemish, ca. 1490. The Walters Art Museum, W. 439.

Roman jewelry is generally slightly less sophisticated, often copying and further developing earlier motifs devised by the Greeks and Etruscans. The so-called mummy portraits, dating from the 1st–4th centuries A.D., from Roman Egypt portray men, women, and children often adorned with multiple jewelry pieces. Comparisons with excavated objects reveal how accurately these paintings record the jewelry fashionable in this period. It was the Romans who introduced the custom of giving rings for official (rewards) and private (betrothal, wedding) purposes, and many of the motifs they introduced remained popular for centuries, like the clasped hands on betrothal rings.

During the 4th century, the primary center of power and culture in Europe shifted from Rome and the West to Constantinople (present-day Istanbul) and the East, and Christianity became the dominant religion. The vast Byzantine Empire extended from Asia Minor into Eastern Europe. Its diversity of cultures is evident in its jewelry, combining Greek and Roman traditions with Oriental influences, which are reflected in the recurring stylized geometric patterns and openwork animal figures. The jewelry of this period is also noted for its intricate metalwork, fine enameling, and lavish use of stone.

During the 12th–15th centuries, jewelry became rare due to a shortage of gold and

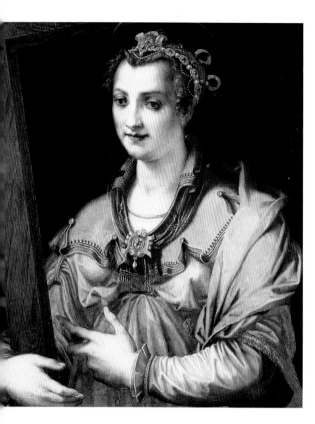

Francesco Morandini, called Il Poppi (1544–97), St. Helena, Italian (Florence), 16th century. The Walters Art Museum, 37.1096.

gemstones, and was almost exclusively worn by courtiers and high clerics. The objects were mostly religious in theme and often functional, like belts, brooches, or clasps for ecclesiastical and secular garments. In the later Middle Ages, gradual changes could be detected, as the rising urban middle class joined the goldsmiths' clientele; as a result of the Crusades, materials also became more readily available and thus affordable. The increasingly opulent garments of the medieval courts were complemented by lavish jewelry, and the drop of the neckline as well as the open sleeves of women's dresses encouraged the reintroduction of necklaces, pendants, and bracelets. Devotional objects, often containing relics, were prevalent, but the demand for secular pieces was growing.

During the Renaissance and baroque periods, jewelry production reached new heights. Sumptuous materials, multiple colors, and complex designs characterize pieces dating to the 16th–17th centuries. Pendants and hat badges with religious, mythological, and genre motifs predominated. Enamelers honed their skills and created works of unprecedented intricacy, responding to and fostering the taste for elaborate floral designs incorporating superb stones. In the 17th century, watches became an essential accessory. The diamond, with its brilliant appearance, grew in popularity, and its faceting constantly increased in complexity.

By the 18th century, diamonds dominated the art of jewelry making. A clear distinction between luxurious ornaments worn for evening events and less valuable pieces suitable for daily wear had evolved. Diamond-studded, precious jewelry was desirable in the evening as it sparkled in candle-lit rooms, whereas relatively inexpensive materials like semiprecious stones, enamel, crystal, and glass paste were suitable imitations for daytime adornment. The marquise ring, fashionable in the second half of the century, combined diamond sparks with gemstones set against an enameled background, creating celestial or floral patterns. The introduction of the chatelaine, an often richly decorated pendant fastened by a hook to the waistband, allowed men and women to carry around useful items—which were themselves often splendid examples of craftsmanship—like watches or étuis with utensils for writing or sewing.

The 19th century is characterized by rapidly changing trends. To meet the demand created by the burgeoning, affluent middle classes of Europe and America, decorative arts including jewelry became increasingly mechanized and responded to fluctuating tastes. Two major themes prevailed: a tendency towards naturalism and a strong interest in the jewelry of earlier periods. With the rise of Napoleon in France in the late 18th century—especially

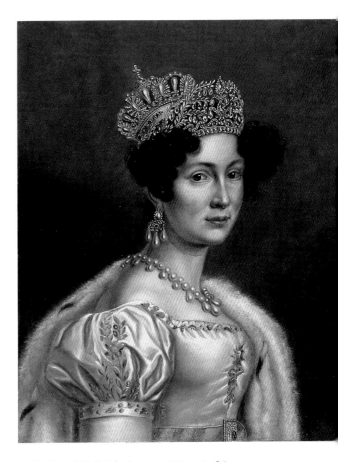

Studio of Joseph Karl Stieler (1781–1858), Portrait of Queen Therese of Bavaria *(1792–1854), German (Munich), ca. 1825–26. The Walters Art Museum, 37.1833.*

his efforts to emulate within his court the splendor of imperial Rome, and his expeditions to Egypt, which fueled interest in that country's glorious past—neoclassical jewelry imitating ancient pieces and especially cameos became all the rage. Masterpieces of archaeological jewelry inspired by recent excavations were created by the Castellani workshop in Rome and by Giacinto Melillo (1845–1915) in Naples. But the influence of other periods, including the Middle Ages and the Renaissance, was also evident in the nostalgic quality of 19th-century jewelry. One of the most prominent styles was the Gothic Revival, which swept France, Austria, and England. Exotic jewelry was inspired by art from such distant lands as India and Algeria, which became increasingly familiar to Europeans in the age of colonialism and among ever-expanding archaeological as well as ethnological interests. As travel became more common,

"souvenir jewelry," of which cameos and pieces with micromosaics displaying romantic landscapes or genre scenes were most popular, was crafted for tourists. The romantic ideals of the 19th century were also reflected in jewelry and expressed such sentiments as love, friendship, or mourning. Many pieces contained a miniature portrait or held a lock of hair of a dear friend, loved one, or family member, and could even be made completely out of hair. In the late 19th and early 20th centuries, artists such as René Lalique (1860–1943) and the craftsmen of Tiffany & Co. produced breathtaking pieces of jewelry. These contemporaries of Henry Walters used an abundance of precious stones and experimented with new materials like horn and steel. The truly new Art Nouveau style rejected the copying of the past and the mass-produced, "flashy" jewelry of the 19th century in favor of original pieces with a high aesthetic appeal.

SABINE ALBERSMEIER
Assistant Curator of Ancient Art

THE
ESSENTIAL COLLECTION

Henry Walters' interest in and appreciation of the jewelry of all

periods is attested by the depth and magnitude of the museum's splendid

holdings. The exquisite array of pieces allows visitors and scholars alike to explore

nearly 5,000 years of jewelry. Presented here is a small, but essential, selection of some of

the most exquisite treasures in the collection, which have been organized by culture

and arranged in chronological order. The museum continues to

expand the variety and range of its holdings through

purchases and gifts that perpetuate

the spirit of giving established

by Henry Walters.

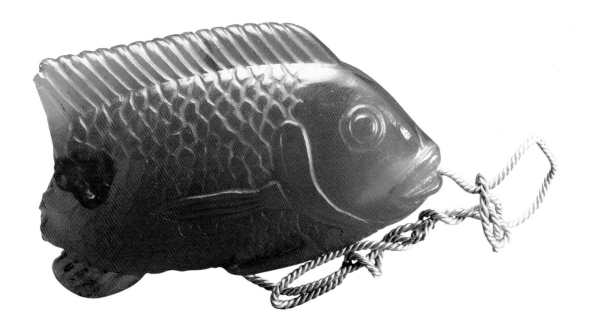

TILAPIA FISH AMULET

Egyptian, New Kingdom, 18th dynasty,
14th century B.C.
Carnelian, gold
L: 1 in. (2.5 cm)
42.196, acquired by Henry Walters,
1926

Fish were not only a major staple in the diet of the ancient Egyptians, but many species were also worshiped as gods. This exceptional fish pendant depicts a *Tilapia nilotica*, a common species in the Nile. It was appreciated for its taste, and was also regarded as a symbol of rebirth and resurrection because it carries its eggs in its mouth and was, therefore, believed to be self-created. Carnelian was popular in the New Kingdom and was used especially for rings, pendants, and inlays.

Ring with Reclining Ram

Syro-Palestinian, 14th–13th century B.C.
Electrum, cast and chased
H: 1 ⅞ in. (4.8 cm); D: ⅞ in. (2.2 cm)
57.970, acquired by Henry Walters

This impressive ring is decorated with chased
geometric patterns on the hoop and a reclining
ram on top. The lotus ornaments on the sides
indicate Egyptian influence. Rings like this
would most likely have been worn by high-
ranking officials or priests.

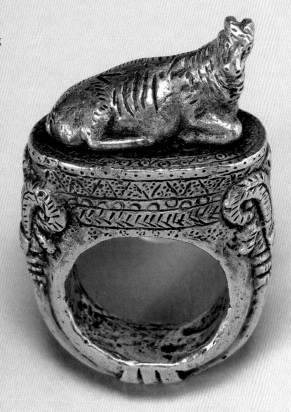

LION TERMINAL FROM AN ARMLET

Iranian, ca. 9th–8th century B.C.
Gold
L: ¹⁵⁄₁₆ in. (2.4 cm)
57.1558, acquired by Henry Walters, 1911

This charming lion, whose hindquarters are fluted
tubes, is executed in a detailed and lively fashion.
The reclining animal once faced another lion, and
together they formed the terminals of a bracelet.
The hoop was most likely made out of thick gold
wire, of which only traces remain inside the tubes.

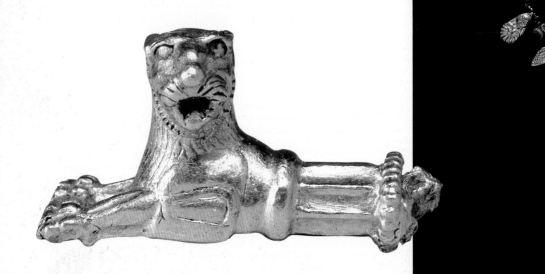

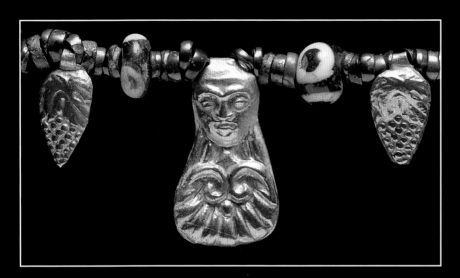

ETRUSCAN NECKLACE WITH RELIEF PENDANTS

Etruscan, 7th–6th century B.C.
Gold, silver, zinc, glass
L: 16 ⅛ in. (41.5 cm); Glass beads: max.
D: ¼ in. (0.7 cm); Zinc beads: max.
D: ³⁄₁₆ in. (0.4 cm); Gold pendants:
max. H: ⅞ in. (2.2 cm)
57.1676, museum purchase, 1941

Etruscan necklaces often combined a great variety of beads and pendants made from different materials. This arrangement of 202 zinc beads, 23 glass beads, and 23 gold pendants is a reconstruction of the likely original. The gold leaves are worked in repoussé and represent either a human head with a palmette or a bunch of grapes.

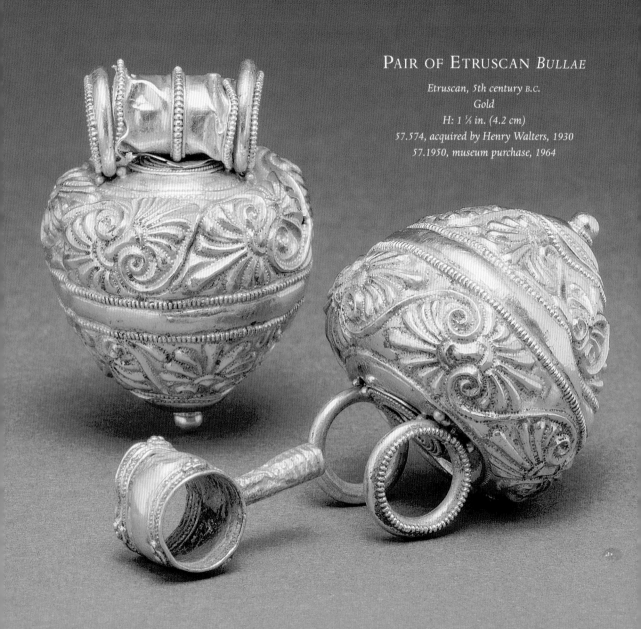

Hollow pendants like this, called *bullae* (singular *bulla*), contained protective charms or perfume and were worn as amulets, especially by children. A stopper at the top, held in place by a chain or cord, secured the contents. The heart-shaped bodies of these Etruscan *bullae* are decorated with detailed palmettes and tendrils worked in repoussé and have intricate smooth or twisted wire applied to the surface. Henry Walters purchased the first *bulla* in 1930; its companion was discovered 34 years later and bought by the museum to reunite the pair.

PENDANTS IN THE SHAPE OF RAM HEADS

Punic, 5th–4th century B.C.
Glass
L: 1 in. (2.5 cm) and ⅞ in. (2.2 cm)
47.96, acquired by Henry Walters and
47.97, acquired by Henry Walters, 1913

Miniature glass pendants in a large variety of colors and shapes can be found all over the Mediterranean world and were probably produced in several glass-making centers, including Carthage, Iran, and Syria. These objects were distributed through the expansive, widespread trade routes established by the Phoenicians. Rams were considered fertility symbols, and these pendants likely also had a protective function and were intended to ward off evil.

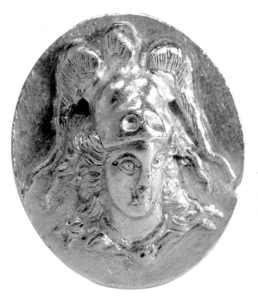

RING WITH THE HEAD OF ATHENA

Greek, Hellenistic period, 3rd century B.C.
Gold
⅞ x ¹³⁄₁₆ in. (2.3 x 2 cm); D: ¹⁵⁄₁₆ in. (2.4 cm)
57.1027, acquired by Henry Walters, 1926

This gold ring depicts the Greek goddess of wisdom and war, Athena, in a lively manner—with flowing hair, a large triple-crested helmet, and the characteristic aegis (shield or breastplate) around her neck.

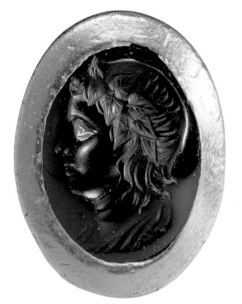

RING WITH DIONYSUS

Greek, Hellenistic period, 3rd century B.C.
Gold, garnet
1 x 1 ⅛ in. (2.5 x 2.8 cm); D: 1 ⅛ in. (2.8 cm)
57.1699, museum purchase, 1942

This massive gold ring has a convex bezel set with a garnet intaglio representing a young man crowned with an ivy wreath. This image could either be an image of the wine-god Dionysus or a portrait of King Ptolemy IV Philopator (221–204 B.C.) in the guise of this deity.

GREEK HOOP EARRING WITH LION HEAD

Greek, 4th–3rd century B.C.
Gold
L: ¹³⁄₁₆ in. (2.1 cm)
57.1665, museum purchase, 1941

Hoop earrings, worn in pairs, with animal-head finials were popular during the Hellenistic period. This lion-headed example represents the most common type, which appeared in many different sizes. To create the body of the hoop, very thin wire is wound around a tapering core of gold. The earring is fastened by hooking the thin end of the hoop through a loop in the lion's mouth.

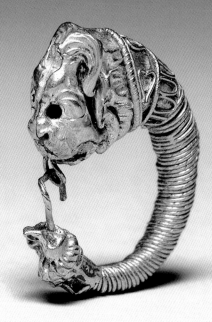

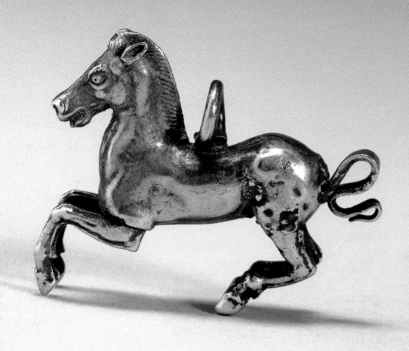

GREEK HORSE PENDANT

Greek, 3rd–1st century B.C.
Gold
$^{15}/_{16}$ x ½ in. (2.4 x 1.3 cm)
57.1728, museum purchase, 1943

From very early on, horses played a major role in Greek culture, and this is reflected in numerous statuettes, reliefs, and vases. In jewelry though, horses are rare, which—along with its superior execution— makes this pendant exceptional. The body was made from two pieces, and then the ears, forelegs, tail, and the ring on the back were added.

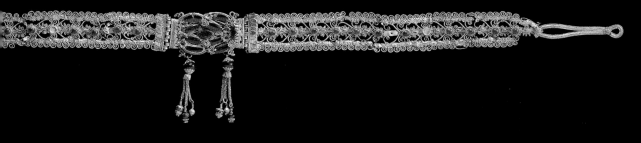

GREEK DIADEM

Greek, 3rd–2nd century B.C.
Gold, garnet, enamel
L: 17 ¾ in. (45.1 cm)
57.1541, acquired by Henry Walters, 1905

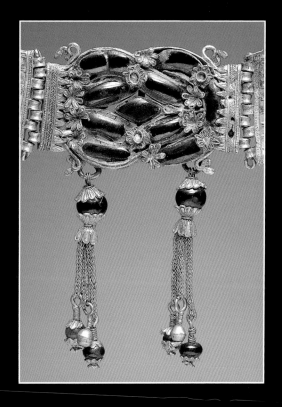

High-ranking or wealthy Greek women often wore elaborate diadems and hairnets of gold and gemstones as part of their jewelry. The centerpiece of this intricate openwork diadem is adorned with a large Hercules knot, inspired by the one the hero used to tie the paws of the lion skin he wore. Due to its protective quality, it also became important in marriage symbolism and was a common motif for women's jewelry of the Hellenistic period, and in royal Macedonian art more generally. The Roman author Pliny even attributed healing qualities to the Hercules knot. This elaborate example is decorated with a miniature snake on each of the four edges, twelve gold rosettes, and two long tassels, which would be placed on the forehead.

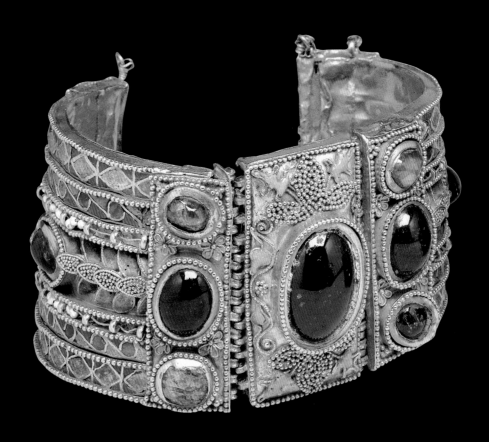

BRACELETS FROM THE OLBIA TREASURE

Greek, 1st century B.C.
Gold, garnets, amethysts, emeralds, pearls, glass, enamel, various stones
(some of them modern replacements)
57.375: 2 1/16 x 3 1/8 in. (5.3 x 7.9 cm); 57.376: 2 1/16 x 2 7/8 in. (5.3 x 7.3 cm)
57.375 and 57.376, acquired by Henry Walters, 1921

These outstanding examples of jewelry from the 1st-century-B.C. Greek colonies in the Black Sea region are purported to belong to the famed Olbia treasure, named for the town in present-day Ukraine in which it was discovered at the end of the 19th century. Whether the bracelets, necklaces, earrings, dress ornaments, and other items in the Walters' collection really came from the same tomb remains unclear. These impressive bracelets have a centerpiece linked by hinges to the two arms. Each bracelet can be closed with a pin that runs through intertwining hoops. The lavish embellishment includes granulation, cloisonné work, and beading as well as multicolored enamel and gemstone inlays in various settings. Using multiple colors and sizes of gemstones became common in Greek jewelry making after the conquest of the East by Alexander the Great (356–323 B.C.), which opened up new trade routes and introduced the Greeks to Oriental styles.

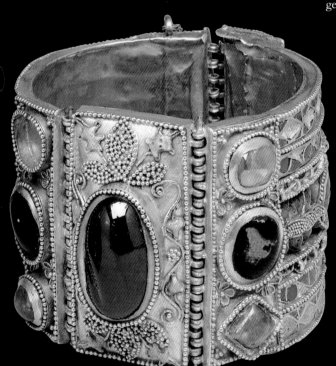

PAIR OF ROMAN SNAKE BRACELETS AND RING

Roman, 1st century A.D.
Gold
Ring: $^{13}/_{16}$ x $^{13}/_{16}$ in. (2 x 2.1 cm); D: 3.7 cm;
Bracelets: max. D: 2 $^{13}/_{16}$ in. (7.2 cm)
57.2163, gift of Mr. Furman Hebb, 1990
57.534 and 57.535, acquired by Henry Walters, 1912

Solid-gold bracelets and rings in the form of snakes were among the most popular objects in Greek and Roman jewelry. The bracelets were often worn in pairs, either on the wrist or on the upper arm. The snakes symbolize fertility and were intended to ward off evil.

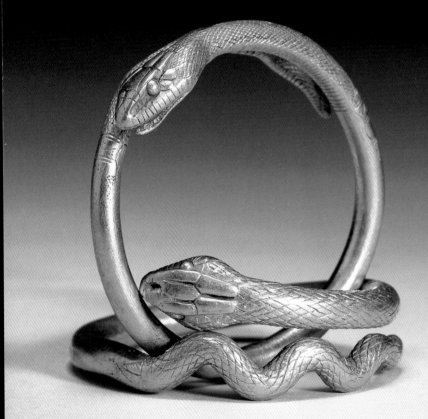

SECTION OF A BELT

Early Byzantine (Constantinople?),
late 4th century
Gold, semiprecious stones
L: 7 ½ in. (19 cm); Medallion:
D: 3 ⅛ in. (8 cm)
57.527, acquired by
Henry Walters, 1931

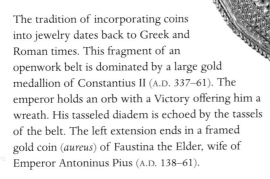

The tradition of incorporating coins
into jewelry dates back to Greek and
Roman times. This fragment of an
openwork belt is dominated by a large gold
medallion of Constantius II (A.D. 337–61). The
emperor holds an orb with a Victory offering him a
wreath. His tasseled diadem is echoed by the tassels
of the belt. The left extension ends in a framed
gold coin (*aureus*) of Faustina the Elder, wife of
Emperor Antoninus Pius (A.D. 138–61).

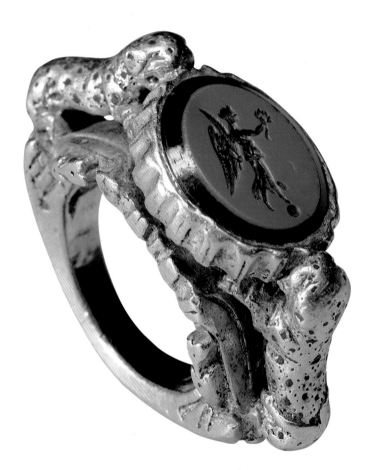

RING

Early Byzantine, 4th century
Gold, nicolo (onyx), niello
¹³⁄₁₆ x 1 ¾ in. (2 x 4.5 cm);
D: 1 ¼ in. (3.2 cm)
57.542, acquired by Henry Walters

The blue nicolo intaglio has a delicate figure of Nike (Victory) standing on an orb and holding a wreath in her outstretched hand. The circular bezel is almost completely separated from the hoop and is held up by a pair of leopards. Other rings of this type contain coins of emperors of the 3rd and 4th centuries. This ring was most likely a reward given by an emperor to a successful military leader.

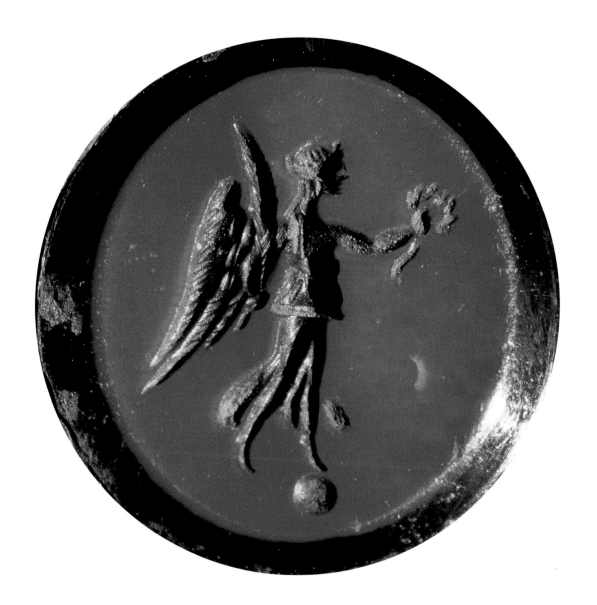

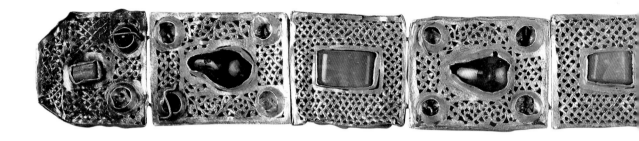

DIADEM

Early Byzantine (Constantinople),
4th–5th century
Gold, amethysts, emeralds
1 ⅛ x 12 ¼ in. (2.8 x 31.1 cm)
57.549, acquired by Henry Walters

Byzantine craftsmen revived the Hellenistic tradition of incorporating multicolored gemstones in jewelry, which was not common during the Roman imperial period. The ten sections of this openwork diadem were each adorned with a central gem and pearls, now missing. The diadem was sewn on a headband of leather or cloth with holes so wearers could adjust the size. Similar pieces were also worn as neckbands. This example would most likely have been worn by members of the imperial family as its amethysts evoke the imperial color purple.

SEAL RING

Byzantine, 9th–10th century
Gold, niello
½ x ⅞ in. (1.3 x 2.3 cm);
D: ¹⁵⁄₁₆ in. (2.4 cm)
57.1053, acquired by Henry
Walters, 1929

This gold seal ring has four lines of Greek inscription in reverse on the oval bezel that translate as: "Lord, protect thy servant Michael the imperial mandator." The monograms and decorative vine scrolls on the shoulders are done in niello.

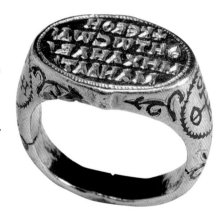

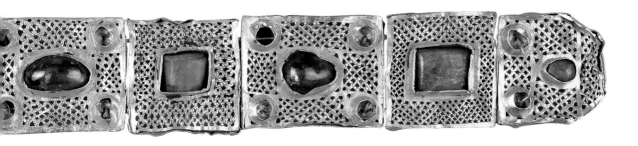

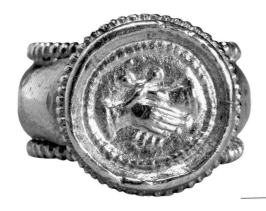

MARRIAGE RING

Early Byzantine, 6th century
Gold
⅝ x ⅞ in. (1.6 x 2.2 cm);
D: ⅞ in. (2.3 cm)
57.1715, gift of Mrs. Saidie A. May, 1942

The hoop and the circular bezel of this gold ring are edged with beads. The motif of the clasped hands, signifying love, betrothal, and marriage, was first introduced in the Roman period and remained a popular symbol until the 19th century. These rings are also called *"fede rings,"* named after the Italian term for good faith and belief.

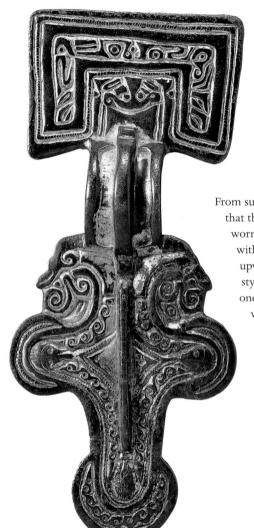

SQUARE-HEADED BROOCH

*Anglo-Saxon
(East Anglia, England),
late 6th century
Gilded bronze
H: 5 9⁄16 in. (14.1 cm)
54.2508, museum
purchase, 1975*

From surviving depictions, we know that these *fibulae* or brooches were worn by men on their shoulders with the square part facing upwards. Depending on the style of the garment or mantle, one or two of these brooches were used to hold it in place. The size and intricacy of this example makes it likely that it belonged to a high-ranking state or church official.

PAIR OF EAGLE FIBULAE

Visigothic (Spain), 6th century
Gold over bronze, gemstones, glass,
meerschaum
5 9/16 x 2 13/16 in. (14.2 x 7.1 cm)
54.421 and 54.422,
acquired by
Henry Walters,
1930

Fibulae (singular *fibula*) were the pins used to fasten ancient and medieval garments. They could vary greatly in shape, size, and decoration. Large *fibulae* in the form of eagles and inlaid with precious stones were especially popular in Visigothic art of the 5th and 6th centuries. Found in Spain, and adorned with crystals, amethysts, and garnets, this pair is among the most impressive to survive and must have conveyed the owner's status splendidly. The tails were originally decorated with three additional adornments.

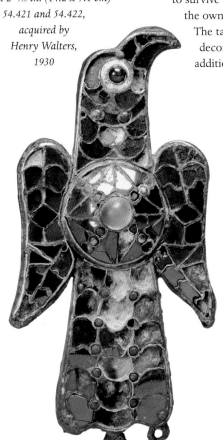
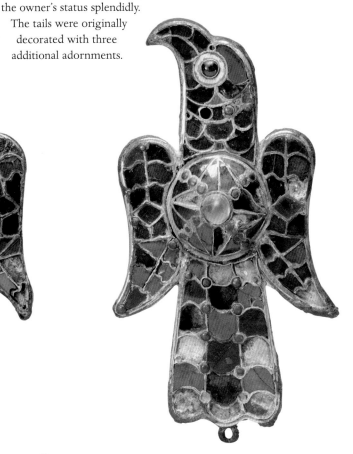

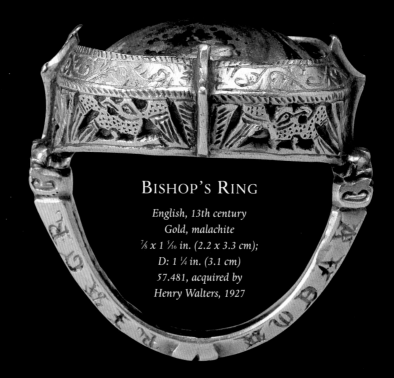

BISHOP'S RING

English, 13th century
Gold, malachite
⅞ x 1 ⁵⁄₁₆ in. (2.2 x 3.3 cm);
D: 1 ¼ in. (3.1 cm)
57.481, acquired by
Henry Walters, 1927

This elaborate bishop's ring has the typical combination of a gold setting with a single, large stone, in this case malachite. The gold is decorated with openwork eagles, animal heads, and floral elements. The malachite is probably meant to resemble "toadstone," a green stone said to be found on the head of a toad and believed to have healing qualities. The inscription on the hoop reads *"AVE MARIA GR/ATIA PLENA D/"* (Hail Mary full of grace). These rings had to be large as bishops normally wore them over gloves on the third finger of the right hand.

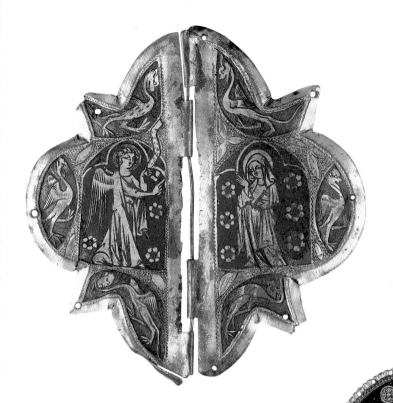

During the Middle Ages, copper mantle clasps with enameled decoration and gemstones were primarily made for church garments. These two examples from France were sewn onto the fabric using the holes around the borders. The morse (clasp) with the Annunciation scene shows the Virgin and Gabriel surrounded by six dragons. This piece surely belonged to an ecclesiastical vestment; however, the other example without figural representation and decorated with gemstones could also have been worn with a secular garment.

CLASPS

French (Paris), ca. 1325
Champlevé enamel on copper
5 ⁹⁄₁₆ x 5 ⅛ in. (14.1 x 13 cm)
44.115, acquired by Henry Walters, 1927

French (Limoges), late 13th century
Gilded copper, champlevé enamel, gemstones
3 ⅜ x 4 ¼ in. (8.5 x 10.8 cm)
44.16, acquired by Henry Walters, 1924

"PAPAL" RING

Italian (Rome), 1408–31
Gilded bronze
H: 1 ⁹/₁₆ in. (4 cm); D: 1 in. (2.6 cm)
54.434, acquired by Henry Walters

Rings of this type mostly date from the 15th and 16th centuries and are decorated with papal arms, mitres, crossed keys, and other ecclesiastical symbols. Their name is somewhat misleading, as it is unlikely that they were actually worn by the popes, given the quantities that were produced and the inexpensive materials used, which would not appeal to the papal taste for precious stones in lavish settings. Therefore, it remains unclear for whom these rings were intended. Their massive size adds to the mystery, as they would probably not have been worn for an extended time. It is possible they were souvenirs given out by the pope to pilgrims. This example bears the arms of Cardinal Gabriele Condolmerio (1408–31), a cardinal's mitre, and a papal tiara.

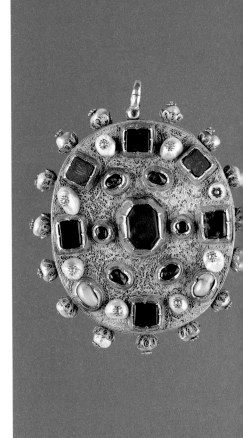

RELIQUARY PENDANT WITH THE VIRGIN AND CHILD

Post-Byzantine (northern Greece),
16th century
Gold, amethyst, rubies, emeralds, peridots?,
pearls, green stones, niello
Case: 3 ⅛ x 2 ¹³⁄₁₆ in. (7.9 x 7.1 cm);
Cross: 2 x 1 ⁷⁄₁₆ in. (5.1 x 3.4 cm)
57.1511a–c, acquired by Henry Walters

This exceptional pendant consists of a reliquary cross inside a hinged case with six small adjacent compartments for relics. The impressive amethyst cameo depicting the Virgin and Child on the lid is surrounded by cabochon rubies and emeralds alternating with pearls. The cross and the outer edge of the case are adorned with additional pearls, and the back of the case is decorated in a similar fashion, omitting the central cameo. A ground of dense filigree covers the front and back of the case, while the inside as well as the inscription and the Crucifixion scene on the cross are done in niello. The text identifies the donor, location, and the time when the piece was crafted, which is rare, perhaps even unique, in Late Byzantine jewelry: the cross was dedicated by the Metropolitan Arsenios of Serres to the monastery of Saint John on the island of Chalke in the middle of the 16th century.

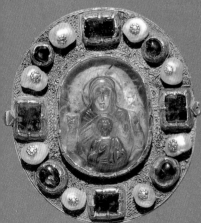

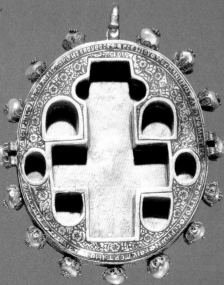

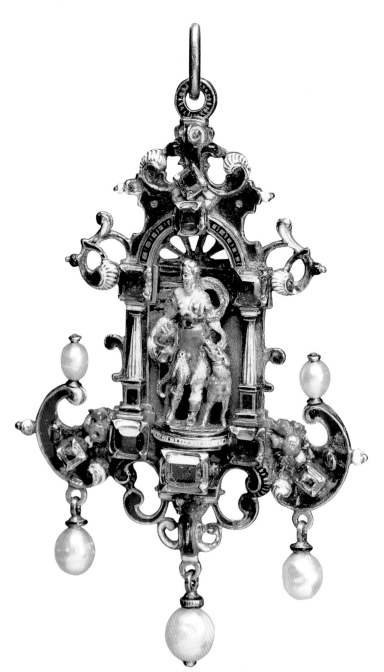

Pendant with the Goddess Diana

South German, 16th century
(restorations: 19th century)
Gold, enamel, diamonds, rubies, pearls
2 ⅝ x 2 ¹⁄₁₆ in. (6.7 x 5.2 cm)
44.442, acquired by Henry Walters

In addition to religious motifs, Renaissance pendants often presented mythological or genre subjects. This example shows Diana, the Roman goddess of the hunt, accompanied by a dog and carrying her bow, quiver, and a horn. Analysis of the enamels confirmed a 16th-century date for the figural group; however, the enameling on the mount proved to be of a later date. As the design of the whole piece is typical of Renaissance pendants, which set a central figure within an elaborate frame of upturned, curvilinear details, it is possible that the later elements on the mount are restorations made due to damage to the original enamel, which chips easily.

Pendant with the Virgin and Child Enthroned

German (Augsburg), 16th/19th century
Gold, enamel, pearls, precious stones
3 15/16 x 2 15/16 in. (10 x 7.5 cm)
44.263, acquired by Henry Walters, 1910

Openwork design, colorful enameling, and religious motifs are characteristic of many opulent Renaissance pendants. This large but delicate example depicts the enthroned Virgin and Child surrounded by a pair of cherubim and intricate scrollwork. Such elaborate pieces would have been owned by Renaissance courtiers. Analysis of the enamels revealed that the central group probably dates to the 16th century. It has been attached to a 19th-century decorative mount of Renaissance-inspired design. Because the Renaissance style experienced a revival in the 19th century, jewelry was frequently copied or forged, often making it difficult without scientific testing to determine if works are original to the period.

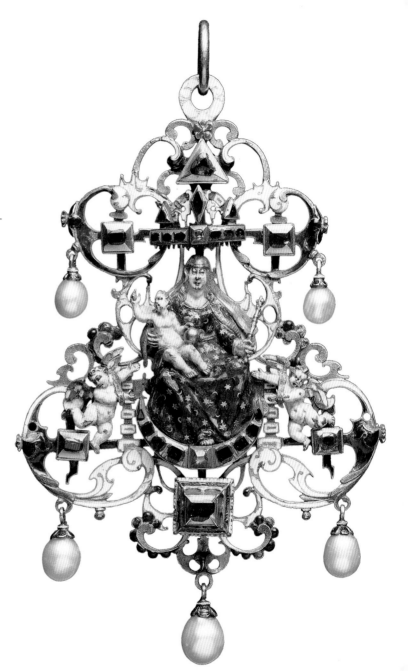

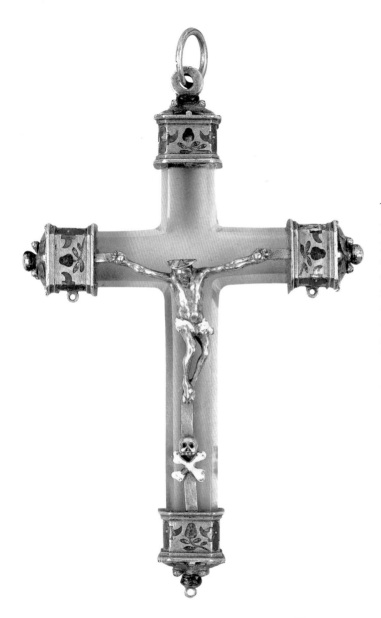

CRUCIFIX

Spanish, 16th century
Gold, rock crystal, enamel
3 ⁵⁄₁₆ x 2 ³⁄₁₆ in. (8.4 x 5.5 cm)
44.511, acquired by Henry Walters

Elaborate crucifixes became increasingly popular during the Renaissance. This example combines a translucent rock crystal crucifix terminating in gold mounts with enameled strawberries (symbols of goodness), pansies (symbols of humility), and multicolored quatrefoils. The skull and crossbones below the feet of Christ appear on many examples. The three loops attached to the side and lower ends of the crucifix once bore pearls.

DIAMOND RING

European, 16th century
Gold, enamel, diamond
H: ¹⁵/₁₆ in. (2.4 cm); D: ⅞ in. (2.3 cm)
44.313, acquired by Henry Walters

This elaborate ring is set with a table-cut diamond in a raised box bezel supported by a structure resembling an inverted pyramid. The ring is lavishly covered with multicolor enameling extending on to the hoop. On each openwork shoulder, a large, grotesque mask is flanked by two enameled volutes.

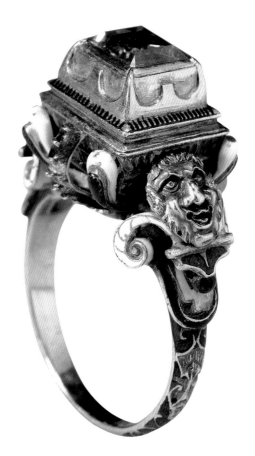

GIMMEL RING

German?, 1631
Gold, ruby, diamond
H: 1 in. (2.6 cm); D: ⅞ in. (2.2 cm)
TL.1985.10.66, on loan from the Zucker Family Collection, 1985

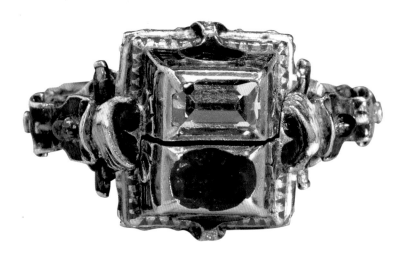

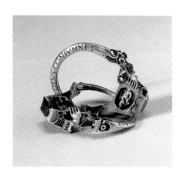

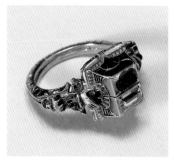

This interesting piece is known as a gimmel ring (also spelled gemmal or gammal, from the Latin *gemellus*, meaning twin), which means it consists of two (as in this case) or more interlocking hoops. This construction is naturally suitable for marriage or betrothal rings. The Latin inscription running over both hoops reads: *"QUOD DEUS CONIUNXIT HOMO NON SEPARET"* (What God has joined, let no man put asunder). The bezel is also divided in two halves, one set with a ruby, the other, with a diamond. Once separated, the two intertwining halves of this ring reveal another element. Under each half of the bezel, normally hidden cavities contain a figure of a miniature human skeleton and a baby. This theme, called *Memento mori* (Remember that you must die), first gained popularity in the late Middle Ages and appears in jewelry as early as the 16th century, displaying such symbols of death as skulls, skeletons, and crossbones. The ring is a reminder that death is inherent in birth. The date of this ring, 1631, is engraved on the inside above one of the cavities.

JEWISH MARRIAGE RINGS

Middle or Eastern European, 17th–18th century
Gold, enamel
IL.2001.10.7: H: 1 ¹³⁄₁₆ in. (4.6 cm); D: 1 ¹⁄₁₆ in. (2.7 cm)
TL.1985.10.142: H: 1 ⁷⁄₁₆ in. (3.6 cm); D: 1 ¹⁄₁₆ in. (2.7 cm)
IL.2001.10.7 and TL.1985.10.142,
on loan from the Zucker Family Collection, 1985 and 2001

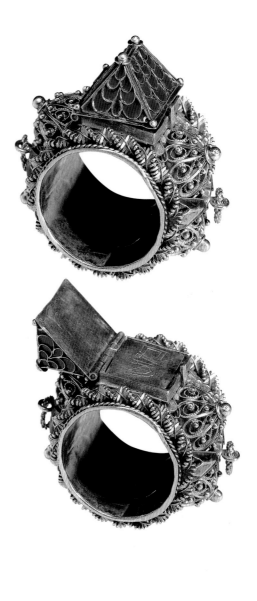

Rings of this type were made especially for Jewish wedding ceremonies, during which the groom would place one on the bride's middle finger. The filigree and enamel floral ornaments are characteristic of this type of ring. Elaborate examples could also be adorned with a complete miniature gabled building, thought to represent Solomon's temple or a synagogue. (The connection between the new husband and wife and their future life together is compared to a building in the Torah.) On the larger of these two rings, this motif is reduced to a gabled rooftop covered with blue enamel. This roof opens up to one side and reveals a gold plate inscribed in Hebrew with the first letters of *"Mazel tov"* (Good luck).

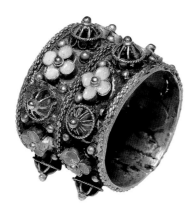

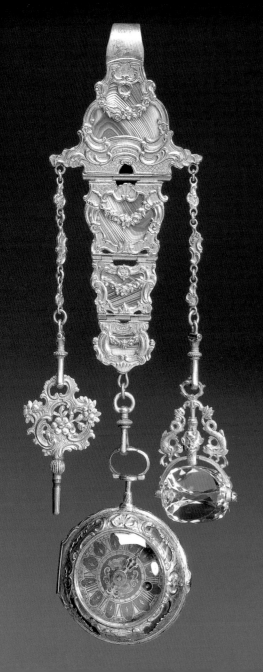

CHATELAINE WITH WATCH

French, 18th century
Gold, gilt metal, agate, rock crystal
H: 6 ¹³⁄₁₆ in. (17.6 cm)
58.16, acquired by Henry Walters

Decorative chatelaines were worn by men and women as pendants and multifunctional devices for carrying utensils like watches, signet seals, and sewing accessories. They were suspended from the waistband by means of the hook at the top, and the flexible, separate panels adjusted to the movements of the wearer. This watch and chatelaine are decorated with elaborate scrollwork and garlands over beautifully striated agate. The chatelaine is fitted with a watch key and a revolving rock crystal seal, neither of which were likely made at the same time as the chatelaine and watch.

Pendant with Ariadne Deserted by Theseus

Italian, 18th century
Gold, chalcedony
1 ¹¹⁄₁₆ x 1 ¹⁵⁄₁₆ in. (4.3 x 4.9 cm)
42.1176, museum purchase, 1942

This large pendant has a detailed mythological scene engraved in the agate. Ariadne is abandoned on the island of Naxos by the Athenian hero Theseus, indicated by the ships on the right leaving the island without Ariadne. Theseus had fled with her from Crete, where she had helped him escape the famous labyrinth commissioned by her father Minos after Theseus killed the ghastly Minotaur and freed the Athenian youths held hostage there. The reason for Theseus's unheroic behavior can be seen on the left side of the pendant: The god Dionysus is approaching in a chariot drawn by goat-legged followers. He has fallen in love with Ariadne, therefore, Theseus deserts her so she will marry the god.

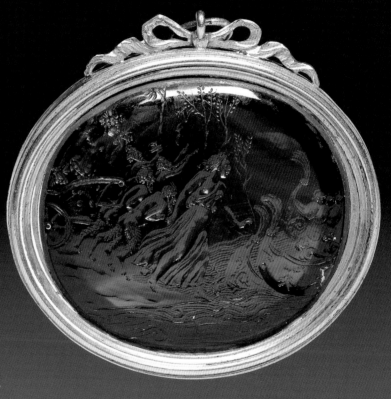

TOILET CASE

German, ca. 1750
Box: gold, wood frame covered with shagreen,
silver, diamonds, emeralds
Utensils: gold, glass, enamel,
ivory, steel
2 5/16 x 1 13/16 in. (5.9 x 4.6 cm)
57.842, acquired by Henry Walters

Small precious cases like this example often contained women's toiletries or sewing tools. This elaborate, heart-shaped case contains two glass scent bottles with gold stoppers, a mirror, a folding ivory writing tablet, a gold bodkin, two gold toothpicks, and a miniature pair of gold tweezers in small, perfectly fitting compartments. A hollow casing for a lead pencil has a silver top set with a diamond for writing on glass. The button used to open the case and the floral element on its front as well as the oval ornament on its top are executed in silver set with diamonds and emeralds.

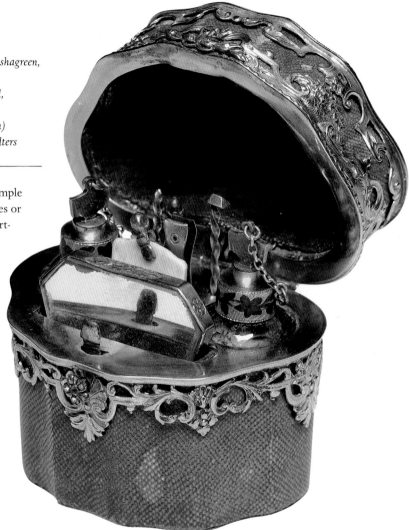

TOILET CASE

English, ca. 1750
Case: gold, diamond; Utensils: gold, silver,
steel, ivory
H: 4 ³⁄₁₆ in. (10.7 cm)
57.953, acquired by
Henry Walters

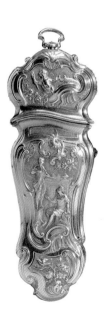

The outside of this elegant gold toilet case is decorated with chiseled and engraved scenes from the Roman poet Ovid's *Metamorphoses*: the seated sculptor Pygmalion admires his creation, the ivory statue of a maiden with whom he falls in love (Book X); and, on the opposite side, Mercury flies above the priestess Herse, the object of his affection (Book II). The case contains a silver-and-gold folding knife, a pair of scissors, a gold bodkin and pencil, a pair of steel tweezers, and an ivory writing tablet. A ring on top indicates that the case could be worn as a pendant so that the utensils would be readily accessible. The button on the side used to open the case is studded with a diamond.

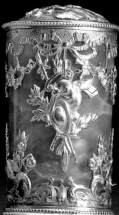
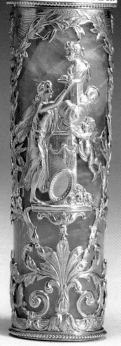

ÉTUI WITH NYMPHS

English or German, ca. 1750
Gold, pink agate, enamel
H: 5 in. (12.7 cm)
57.825, acquired by Henry Walters

This étui, or needle case, is covered with gold reliefs showing nymphs making offerings to the Roman goddess Venus or Ceres, putti flying or seated on clouds, and, at the top, pastoral trophies, all surrounded by delicate floral garlands and scrollwork. The gold inscription on the small horizontal band of white enamel separating the lower part of the case from the sliding lid reads: *"CROYEZ A MES SENTIMENTS AFFECTUEUX"* (With sincere affection).

WEDGWOOD MEDALLION AND SCENT BOTTLE

English (Stoke-on-Trent),
18th century
Wedgwood, Stoke-on-Trent
Blue jasperware, gold
Medallion: D: 1 ¹⁵⁄₁₆ in. (5 cm);
Scent bottle: H: 3 ⁵⁄₁₆ in. (8.4 cm)
48.1971, gift of Miss Elisabeth
Gilman, 1948
48.1570, acquired by Henry
Walters, 1911

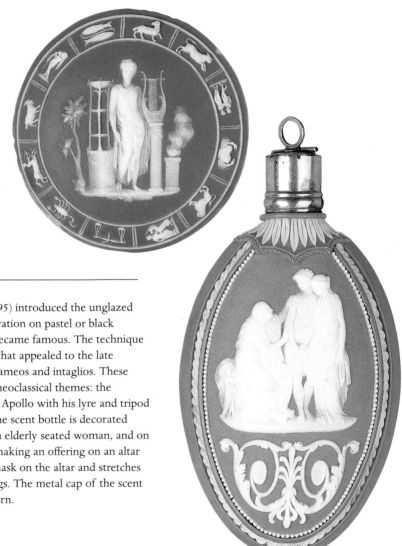

In 1774, Josiah Wedgwood (1730–95) introduced the unglazed jasperware with white relief decoration on pastel or black backgrounds for which the firm became famous. The technique was used for ornamental cameos that appealed to the late 18th-century passion for ancient cameos and intaglios. These two examples have characteristic neoclassical themes: the circular medallion depicts the god Apollo with his lyre and tripod surrounded by a Zodiac border; the scent bottle is decorated with a young couple in front of an elderly seated woman, and on the other side, with two women making an offering on an altar of Love. Eros is hiding behind a mask on the altar and stretches out his hand to receive the offerings. The metal cap of the scent bottle has a loop so it could be worn.

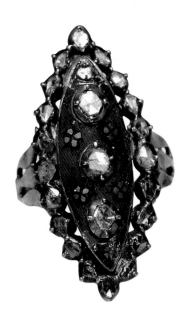

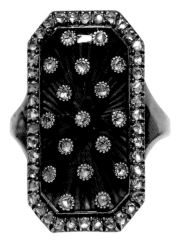

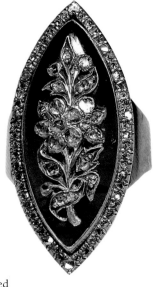

RINGS WITH CELESTIAL AND FLORAL MOTIFS

*European, late 18th century and
early 19th century (57.1789)
Gold, silver, enamel, diamonds
57.1789: H: 1 ⁵⁄₁₆ in. (3.4 cm);
D: ¹¹⁄₁₆ in. (1.9 cm)
57.1792: H: 1 ¹⁄₁₆ in. (2.7 cm);
D: ¹¹⁄₁₆ in. (1.8 cm)
57.1776: H: 1 ⁵⁄₁₆ in. (3.3 cm);
D: ¾ in. (1.7 cm)
57.1789, 57.1792, and 57.1776,
gift of Laura Delano, 1947*

In the late 18th century and into the 19th century, marquise rings set with diamonds on dark blue or red enamel backgrounds became fashionable in Europe. These three examples represent two popular shapes: oval (marquise bezel) and rectangular (shuttle-shaped bezel) set with single diamonds imitating stars in the sky or floral sprays. All are characteristically framed by a border of diamond sparks in silver mounts. The blue enameled rings evoke celestial allusions and were called *"bagues au firmament"* (Rings of the Heavens).

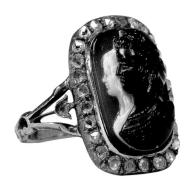

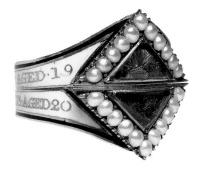

CAMEO RING WITH MARIE ANTOINETTE AND THE DAUPHIN

French, late 18th century
Gold, silver, diamonds, sardonyx
H: ¾ in. (1.9 cm); D: ¹¹⁄₁₆ in. (1.7 cm)
57.1787, gift of Laura Delano, 1947

The rectangular bezel of this ring is set with a sardonyx cameo featuring portrait busts of Queen Marie Antoinette of France (1755–93) and her son the Dauphin (1785–95). The cameo is surrounded by a border of diamond sparks in silver mounts (collets). The forked shoulders each enclose a tulip originally set with a crystal and connect to the channeled hoop.

MEMORIAL RING

English, ca. 1804–5
Gold, enamel, pearls
H: ⅞ in. (2.2 cm); D: ¹³⁄₁₆ in. (2 cm)
44.528, acquired by Henry Walters

This ring commemorates two siblings who are named in the gold inscriptions on white enamel: *"C. M. BURNLEY. DIED. 3 MAR. 1804. AGED 19. and A. E. BURNLEY. DIED. 8 JULY 1804. AGED 20."* The color of the enamel, associated with purity, indicates that they were unmarried. The ring is comprised of two halves that mirror each other and are held together by small pins and sockets. The bezel is divided by two separate triangular compartments with pearl borders, each containing a lock of one sibling's hair. During the 17th and 18th centuries, it became customary in England to commemorate loved ones with memorial rings, which were distributed at the funeral. From around 1770, they often contained miniature portraits or held locks of the deceased's hair in small compartments accompanied by inscriptions identifying the person to be remembered.

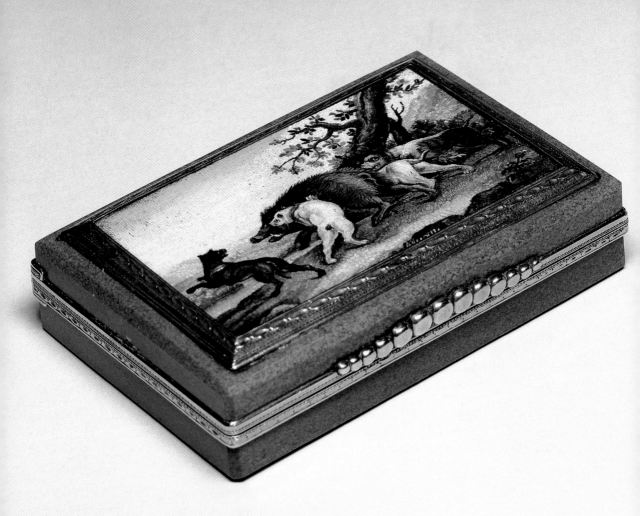

BROOCH AND BOX
WITH MINIATURE MOSAICS

Italian (Rome), early 19th century
Brooch: gold, glass, tesserae;
Box: gold, glass, tesserae, green stone
Brooch: D: 2 in. (5.1 cm);
Box: 2 ½ x 1 %₆ in. (6.4 x 3.9 cm)
43.46 and 43.21, gifts of Miss Katherine Kosmak
and Mr. George Kosmak, 1975

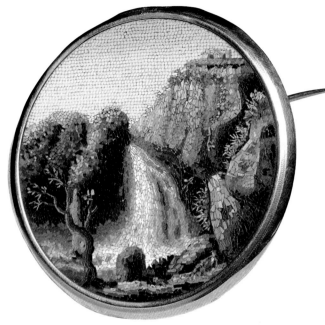

Micromosaics crafted from miniature glass tesserae
(mosaic tiles) decorated paperweights, boxes, and
brooches, which were popular as tourist art and
"souvenir jewelry." The Vatican workshops were
largely responsible for their production and featured
many examples as part of the Vatican's contribution
to 19th-century expositions. The mosaics often
represent genre scenes like the boar hunt on the box,
or scenic landscapes, as on the brooch, depicting the
waterfalls at Tivoli, a well-known site near Rome.

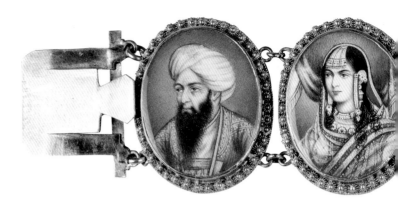

GOTHIC-STYLE BRACELET

Austrian, ca. 1870
Gold, carnelian, malachite, moss agate, amethysts, aquamarines, rubies
2 ¹¹⁄₁₆ x 6 ¹⁵⁄₁₆ in. (6.9 x 17.7 cm)
57.1999, gift in memory of Paul Esmerian, 1972

This extravagant bracelet consists of five arched segments and three foliate segments. Judging from indentations in the original leather case, this piece was originally a diadem with two additional foliate elements rather than a bracelet. All pieces are hinged together and carried out in elaborate openwork decorated with precious stones and scrollwork. The five large pieces imitate Gothic architecture with ogive arches and columns.

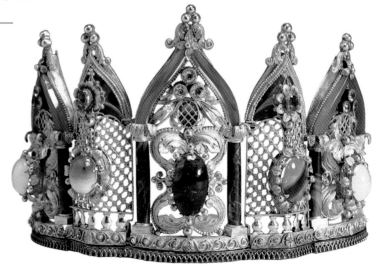

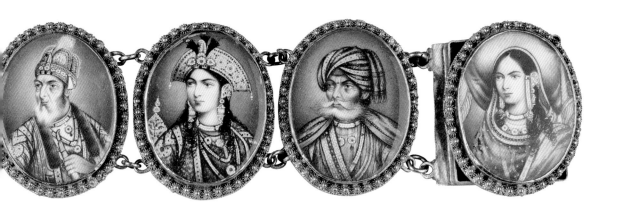

BRACELET WITH
PORTRAIT MINIATURES

Mughal, 1860s
Watercolor on ivory, gold
L: 7 ½ in. (19.1 cm)
38.665, gift of Mrs. Jerry Cascarella, 1999

The six segments of this bracelet feature miniature portraits of three Mughal emperors and their consorts. Indian artists adopted the technique of painting portrait miniatures on ivory with watercolors from British artists living and working in India during the 19th century. This delicate bracelet is, therefore, an interesting example of the cultural exchange between East and West during the period of European imperialism.

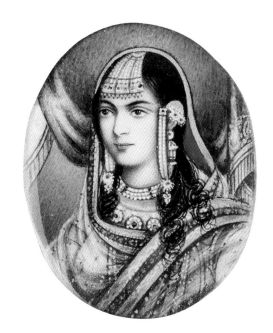

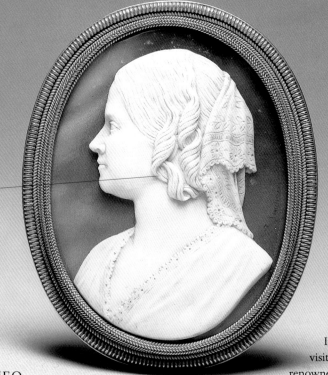

BROOCH
WITH CAMEO
BUST OF ELLEN WALTERS

Italian (Rome), ca. 1862
Shell, gold
H: 2 ⅛ in. (6.7 cm) (with frame)
57.2001, gift of Mrs. Frederick B. Adams, 1972

In 1862, William T. Walters visited the workshop of the renowned jewelry maker Augusto Castellani (1829–1914) in Rome. Walters commissioned this brooch commemorating his wife Ellen, who had died earlier that year. The portrait cameo was carved by the well-known engraver Tommaso Saulini (1793–1864) after a bust of Mrs. Walters by the Maryland sculptor William T. Rinehart (1825–74).

STICKPINS

English (57.1122, 57.2180, 57.2184), American (57.1109,
57.1984, 57.2173), 1870–1910
Gold, silver, diamonds, pearls, crystal, tiger-eye, lapis, enamel
57.1109: H: 2 ⅛ in. (6.7 cm); 57.1122: H: 3 ⅛ in. (7.9 cm);
57.1984: H: 2 ⅞ in. (7.3 cm); 57.2173: H: 2 ¹³⁄₁₆ in. (7.2 cm);
57.2180: H: 3 ⅛ in. (7.9 cm); 57.2184: H: 2 ¹³⁄₁₆ in. (7.1 cm)
57.1109, 57.1122, acquired by Henry Walters; 57.1984, bequest
of August Mencken, 1967;
57.2173, 57.2180, and 57.2184, gift of Mrs. Leslie Legum, 1991

During the early 19th century, stickpins were a popular accessory worn by men as a tie or cravat pin. They came in a variety of precious materials and motifs. So as not to appear feminine, they frequently represented hunting, sporting, or other typically male pursuits. They were also crafted as mourning, commemorative, or souvenir pins. Animals were particularly popular, as reflected in this selection, which includes two hounds, an eagle, a horse, and a mouse on a spoon.

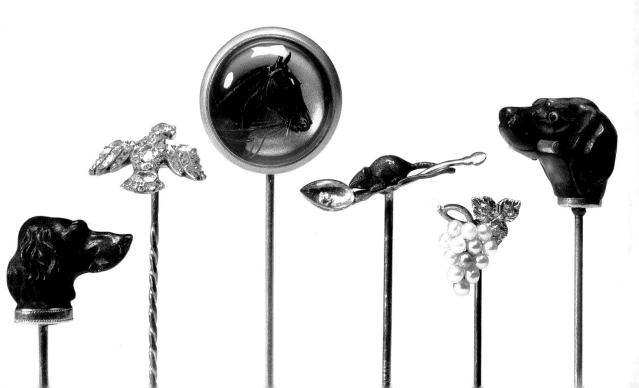

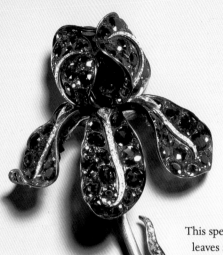

This spectacular iris brooch is composed of a gold stem, three small
leaves set with green demantoid garnets, and six large petals combining
139 sapphires, diamonds set in platinum ribs, and citrines on the
bearding of the three drooping petals. The large size of the brooch,
the variation of the faceted sapphires in size and color intensity, and
the contrast with the bright, sparkling diamonds and citrines create
a stunning effect. The brooch is one of the most magnificent of
Tiffany's jewelry creations in existence. The company and its head
gemologist, George F. Kunz (1856–1932), were famous for their
use of multiple gemstones, especially of American origin,
like the Montana sapphires on this brooch. The corsage
ornament was showcased in the Tiffany pavilion at
the 1900 Paris Exposition universelle, winning the
designer, George Paulding Farnham (1859–1927),
a gold medal for his creations and Tiffany
& Co. the grand prize of the jury.

IRIS CORSAGE
ORNAMENT

American (New York), ca. 1900
Tiffany & Co., New York
Gold, oxidized silver, platinum, sapphires,
diamonds, topaz, demantoid garnets
H: 9 ½ in. (24.1 cm)
57.939, acquired by Henry Walters, 1900

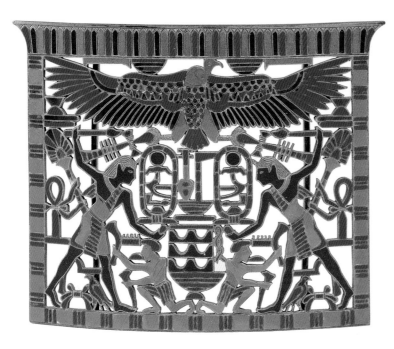

EGYPTIANIZING BROOCHES

American (New York), early 20th century
Tiffany & Co., New York
Silver gilt, enamel
57.1482: 2 ¹⁵⁄₁₆ x 3 ¹¹⁄₁₆ in. (7.5 x 9.3 cm);
57.1483: 1 ⅛ x 2 ⅜ in. (2.8 x 6 cm)
57.1482 and 57.1483,
acquired by Henry Walters

In 1894, J. de Morgan excavated several magnificent ancient pectorals from the tomb of Princess Mereret, daughter of Sesostris III, in Dahshur, Egypt. Soon after this discovery, these faithful replicas were made. Unlike many Egyptianizing pieces, these examples copy the details of the originals without major errors or changes; only the size and materials are slightly varied: silver and multicolored enamels replaced gold, faience, and carnelian. The brooches, in the form of a kiosk, give the names of the pharaohs Sesostris III and Amenemhet III from the middle of the 12th dynasty (19th century B.C.). Below the wings of a protective vulture, the pharaohs are depicted as humans and as sphinxes slaying their enemies.

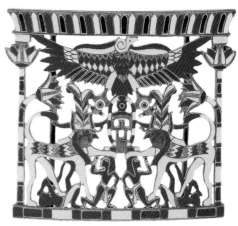

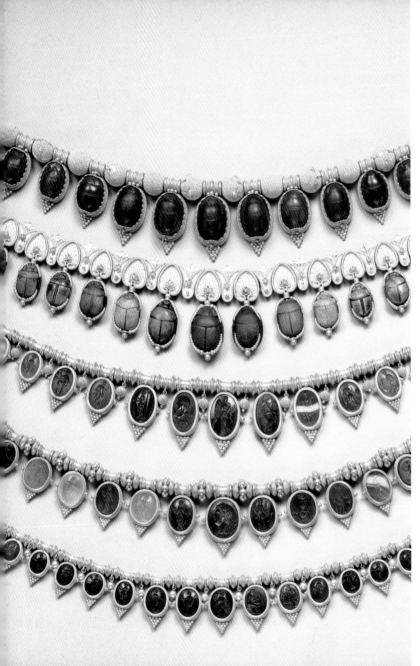

EGYPTIAN-STYLE NECKLACES WITH SCARABS

*Italian (Naples), late 19th
or early 20th century
Attributed to Giacinto Melillo (1845–1915)
Gold, gemstones
57.1531: L: 16 ¾ in. (42.5 cm);
57.1530: L: 14 ⁷⁄₁₆ in. (36.7 cm);
57.1534: L: 14 ¼ in. (36.1 cm);
57.1535: L: 17 in. (43.1 cm);
57.1533: L: 14 ⅜ in. (36.5 cm)
57.1530, acquired by Henry Walters, 1903;
57.1531, 57.1534, 57.1535, and 57.1533,
acquired by Henry Walters*

Archaeological jewelry decorated
with ancient and modern scarabs
was popular in Europe during the
second half of the 19th century.
The Castellani workshop was
famous for its copies of ancient
jewelry, and these necklaces have all
been attributed to Giacinto Melillo,
one of Alessandro Castellani's
apprentices and protégés (57.1530
bears his mark on the clasp). He
later took over Castellani's
workshop in Naples, which
Henry Walters visited in 1909.

DIAMOND NECKLACE

American (New York), ca. 1904
Tiffany & Co., New York
Diamonds, gold, platinum
L: 7 ⁵⁄₁₆ in. (18.6 cm)
57.2121, gift of Mr. and Mrs. Gerson Eisenberg,
in memory of Abram and Helen Eisenberg, 1987

This necklace is a splendid example of Tiffany & Co.'s jewelry
production around the turn of the 20th century, when the
company was famous for its lavish use of diamonds.
Featuring altogether 265 round old cut diamonds, the front
part of the necklace consists of nine round diamond
clusters alternating with ten diadem clusters. On
either side of the clasp are six smaller triangular
cluster sections with a bezel set round
diamond separating them from
each other.

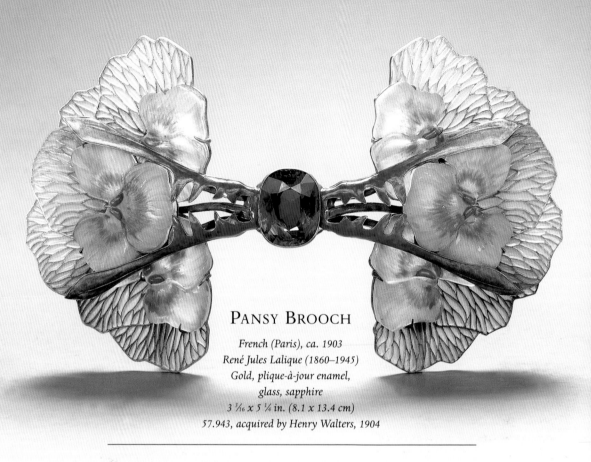

PANSY BROOCH

French (Paris), ca. 1903
René Jules Lalique (1860–1945)
Gold, plique-à-jour enamel,
glass, sapphire
3 ³⁄₁₆ x 5 ¼ in. (8.1 x 13.4 cm)
57.943, acquired by Henry Walters, 1904

This magnificent brooch is an outstanding example of Lalique's extraordinary
floral jewelry creations, which due to their sheer size and delicacy were
probably never intended to be worn. Here, three overlapping pansies on either
side of a central, simulated step-cut sapphire combine molded glass blossoms
with openwork enameled petals growing out of stems also covered with
translucent blue enamel. Henry Walters bought this piece from Lalique in
1904 at the Louisiana Purchase Exposition in Saint Louis, Missouri.

EVENING BAG

French or American, early 20th century
Gold, sapphires, diamonds
5 ⅛ x 6 ¹¹⁄₁₆ in. (13 x 17 cm)
57.2204, gift of Mr. and
Mrs. Robert Levi, 1991

Evening bags and
purses made out of gold and
adorned with precious stones were
popular in the early 20th century and were
produced by famous jewelry makers like
Tiffany & Co. This evening bag is made of meshed
green gold with twenty-five diamonds and twenty-four
sapphires lining the flap. A small detachable purse is linked
by a chain to the inside of the larger bag. An inscription
engraved on the inside of the frame identifies a former owner:
"May 20, 1913 Mrs. Alexander Hecht Baltimore Md."

GLOSSARY

Cabochon

A stone polished to give it a smooth, rounded top surface.

Champlevé

A technique in which hollowed-out areas of metal are filled with colored enamel and fired, causing the colors to merge and blend.

Cloisonné

A technique in which flat strips of metal are soldered edge upwards to a metal surface, creating cells or compartments (*cloisons*) that are filled with different colored enamel pastes and then fired.

Electrum

A naturally occurring alloy (mixture) of gold and silver also known as white gold.

Engraving

The process of cutting away a surface (metal or other) with a sharp instrument in order to create a linear design.

Filigree

Thin strands of gold or silver wire that have been twisted and soldered to create decorative patterns.

Granulation

A technique in which tiny gold balls are fused to a metal surface.

Intaglio

An engraving or incised design cut into stone, glass, or metal using drills, abrasives, and engraving tools; when the finished work is pressed into a softer material such as wax, the impression shows the reversed image in relief.

Niello

Any of several metallic alloys combining sulfur with silver, copper, or lead and that have a deep black color. Used for decorating silver and, less frequently, gold.

Plique-à-jour

A technique in which enamel is used over an openwork design, so that the light strikes it from the back.

Repoussé or Embossing

A technique in which the design is hammered out from the back of the metal sheet to create raised relief decoration.

Rings

Bezel: The top part of a ring containing the stone, device, or other ornament.

Shoulders: The sections of a ring hoop closest to the bezel or central ornament.

Hoop: The part of a ring that surrounds the finger.

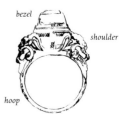